ABOUT VALERIE

MW00799288

Chalkboard artist and hand letterer Valerie McKeehan has been drawing and illustrating since childhood. A lifelong creative, her passion for commercial art began simply and without pretense: producing hand-lettered signs for her father's business. In 2012, newly wedded and drawing from a love of visual storytelling honed through her career in advertising, Valerie transformed an old picture frame into a "McKeehan's Café" chalkboard for the kitchen. She instantly fell in love with chalkboard art.

Drawn to the simplicity of chalk and the nostalgia that it inspires, Valerie opened her online chalkboard boutique, Lily and Val, in 2012. Whimsical and undeniably handcrafted, her designs are honest and authentic, at home with their imperfections and unique character. Working out of her home studio in Pittsburgh, Pennsylvania at a desk constructed by her husband, she lovingly creates each piece entirely by hand, from sketch to slate, illustrating inspirational quotations or simply depicting everyday subjects that inspire her work, such as coffee and cooking.

It's the spontaneity of life's playful, everyday pleasures that inspires Valerie. The smallest things are the most important things: a few words transforming a room into a cozy space, an illustration that makes you smile. Valerie revels in mixing simple nostalgia with a modern style of pretty-whimsy to create beautiful designs that are lovingly made.

Valerie's work has been featured in many publications, media outlets, and noteworthy blogs, including: The Food Network, *The Knot Magazine*, *Good Housekeeping Magazine*, HGTV.com, *Huffington Post*, *Real Simple.com*, *Flea Market Style Magazine*, *Smart Magazine*, *Martha Stewart Weddings.com*, *Country Living.com*, *BuzzFeed*, *Life & Style Weekly.com*, and *Style Me Pretty*.

She is the author of the book *The Complete Book of Chalk Lettering: Create & Develop Your Own Style*, *Chalk-Style Botanicals Deluxe Coloring Book*, *Chalk-Style Holiday Coloring Book*, and *Chalk-Style Celebrations Coloring Book*.

CREATIVE PROCESS: HOW CHALK ART BECOMES A PERMANENT DESIGN

Each piece I create starts out as a hand-lettered and illustrated design. Most of my designs begin as a pencil sketch. When I'm sketching, I usually have a quote in mind or something that I have to get out on the page. I use the sketch to help determine the layout of the finished piece and the font styles I would like to use. I change my mind lots of times and keep making adjustments until I'm happy with the design.

When the design is ready, I take it to one of my chalkboards. When I reach this stage, I work in layers, starting with a rough sketch first. Then I go back and refine the design by adding details, sharpening the letters, creating shading—all of the things that will make the piece really pop and give it a finished look.

When I've finished my chalkboard design, I take a photograph of it and import it to my computer as a digital image. There is something so real and authentic about hand-drawn, hand-lettered art, but by bringing the art onto the computer, I can share it with you!

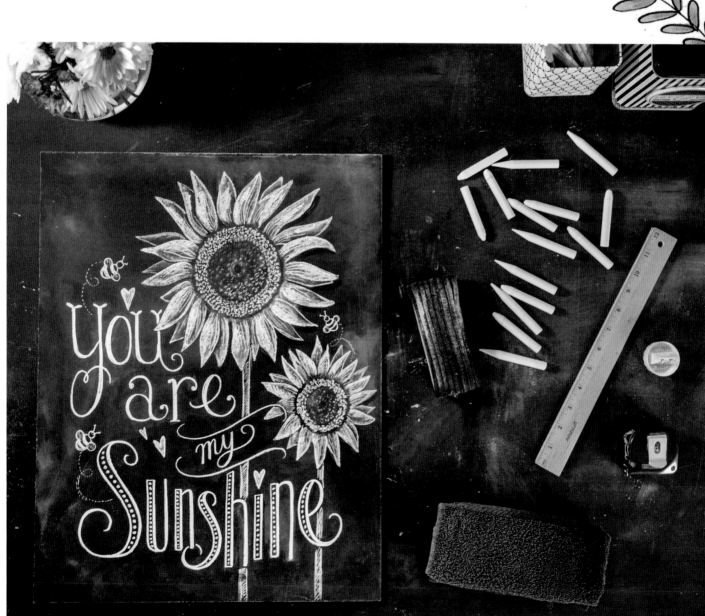

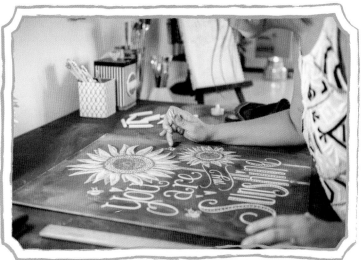

When I'm happy with my pencil sketch, I draw the design on one of my chalkboards and refine it by adding detail and shading.

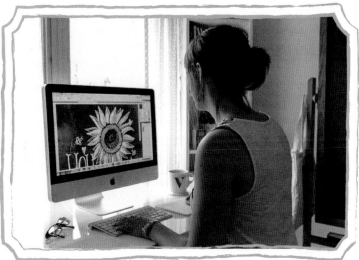

Almost every design starts as a rough pencil sketch where I make decisions about the layout and font style I will use.

When the chalkboard design is finished, I take a photograph of it and import it to my computer where I can make further revisions if I want to, like adding color.

HERE ARE SOME MORE EXAMPLES OF CHALKBOARD ART THAT I HAVE CREATED!

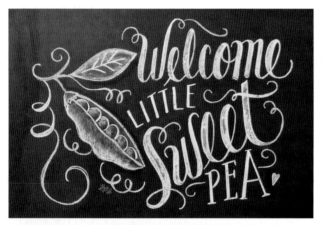

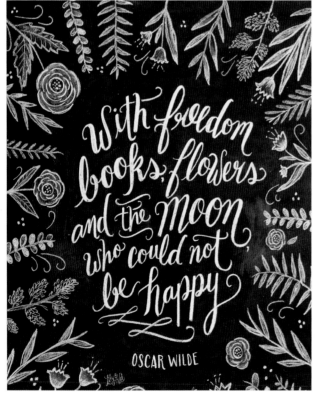

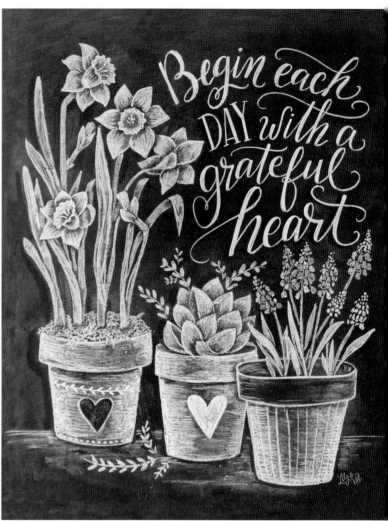

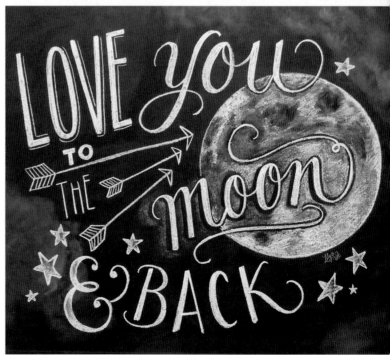

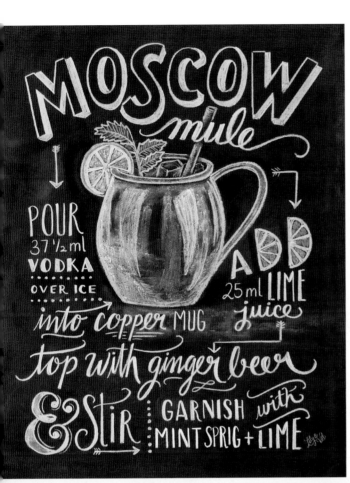

MOSCOW *mule*

POUR 37½ml VODKA OVER ICE
into copper MUG
ADD 25 ml LIME juice
top with ginger beer
& Stir
GARNISH with MINT SPRIG + LIME

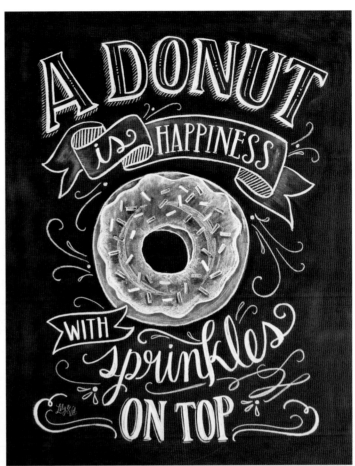

A DONUT is HAPPINESS
WITH sprinkles ON TOP

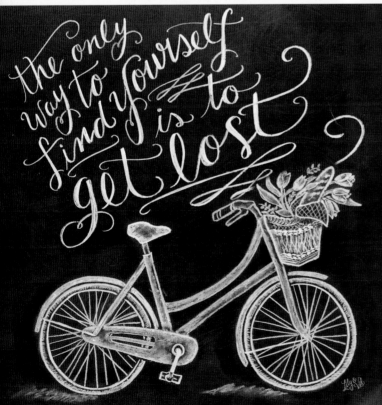

the only way to find yourself is to get lost

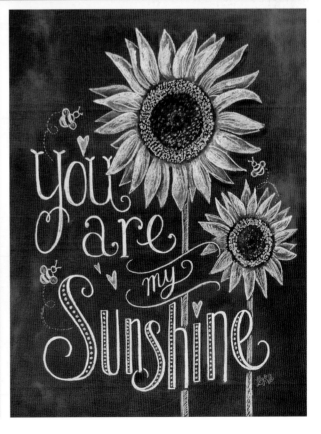

you are my Sunshine

COLOR THEORY

Picking the colors you want to use for a design can be intimidating, but it doesn't have to be! Some basic understanding of color theory will go a long way toward making you feel more comfortable about choosing colors. Ultimately, though, it's good to remember that there is no right way or wrong way to color a design in this book, so don't be afraid to dive in!

It all starts with the primary colors red, yellow, and blue. These three colors can be mixed to create a whole rainbow, but they cannot be created by mixing other colors—this is why they are "primary." If you mix two primary colors, you will get the secondary colors orange (red + yellow), green (yellow + blue), and purple (blue + red). Mixing a primary color and a secondary color will result in a tertiary color. These include orange-yellow, yellow-green, green-blue, blue-purple, red-purple, and orange-red. Any primary, secondary, or tertiary color can be darkened or

lightened by the addition of white or black. The result is a tint or shade of the original color. For example, pink is a tint of red created by adding white, and burgundy is a shade of red created by adding black.

Take a look at the color wheel. It is your most helpful tool when it comes to understanding how colors relate to one another. Think of the color wheel as having two sides. On one side are the warm colors yellow, orange, and red. On the other side are the cool colors green, blue, and purple. Warm colors are bold and invoke excitement. They will pop out of your design, especially when paired with cool colors. Cool colors are calm and invoke relaxation and peacefulness. They will recede in a design. Warm colors will always pair well with one another and cool colors will always pair well with one another.

Another handy color relationship you should be aware of is analogous colors. Analogous colors are next to

one another on the color wheel. One reason warm colors and cool colors go well together is because they are analogous, but you don't have to limit yourself to warm and cool colors only. A mix of warm and cool analogous colors will make a great color scheme. For example, blue and green (both cool) pair well with yellow (warm).

One final color relationship for your arsenal is complementary colors. Complementary colors are directly opposite one another on the color wheel. If you look at the color wheel, you'll see that all complementary pairings contain a warm and a cool color. For example, orange (warm) and blue (cool). As their name suggests, complementary colors "complement" one another. They also stand out against one another more than they do against any other color. You can use this relationship to create some real impact!

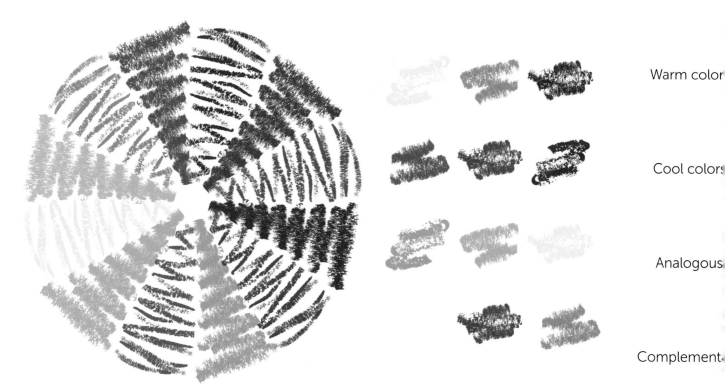

Warm colors

Cool colors

Analogous

Complement

TIPS AND TRICKS FOR CHALKBOARD ART

The black chalkboard background used for these pieces adds another element to consider when coloring. Here are some tips and tricks that you might find helpful. Also be sure to check out the colored designs on the following pages for inspiration.

Keep it light and bright. Remember that you're working on a black background. This means the colors that will be the most visible are bright ones, like warm colors and neons. If you prefer a cool color palette, try using lighter pastel shades of your favorite colors, like light blue and green, instead of dark shades like navy and forest green.

Add to the background. Just because the background is black doesn't mean you can't add to it. Use light-colored pencils and gel pens to add your own lettering, flourishes, and patterning to the existing designs. Gel pens can even be used to apply additional detail to an area that's been colored with markers or colored pencils.

Lay it on thick. You can give your piece lots of dimension by layering colors and adding shading. This will make the color elements of your design stand out even more against the simple, dark background.

Let it be. White lettering on a black background is THE classic chalk look. If you like that simple style, consider leaving the letters in a design white and coloring everything else. Or, for a modern twist, color the letters, too!

Rough it up. It might be tempting to smooth out your coloring to avoid texture and imperfections, but these look perfectly natural in a chalk piece. Embrace the texture your colored pencils create or the lines you might get from overlapping your markers. These imperfections will add character to your piece and make it unique.

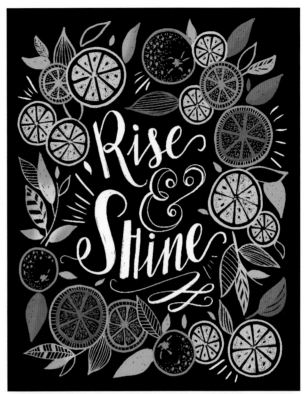

Bright, warm colors like the yellows, oranges, and light greens used in this piece will stand out against the dark chalkboard background.

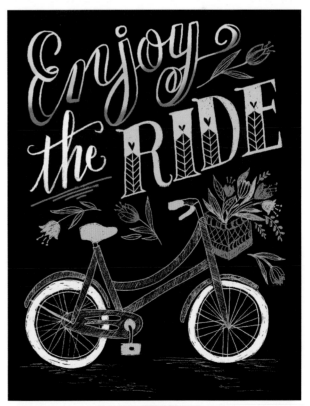

Don't be afraid of texture! It pairs beautifully with chalkboard art. Loot at the texture created on the bike and the ground in this design.

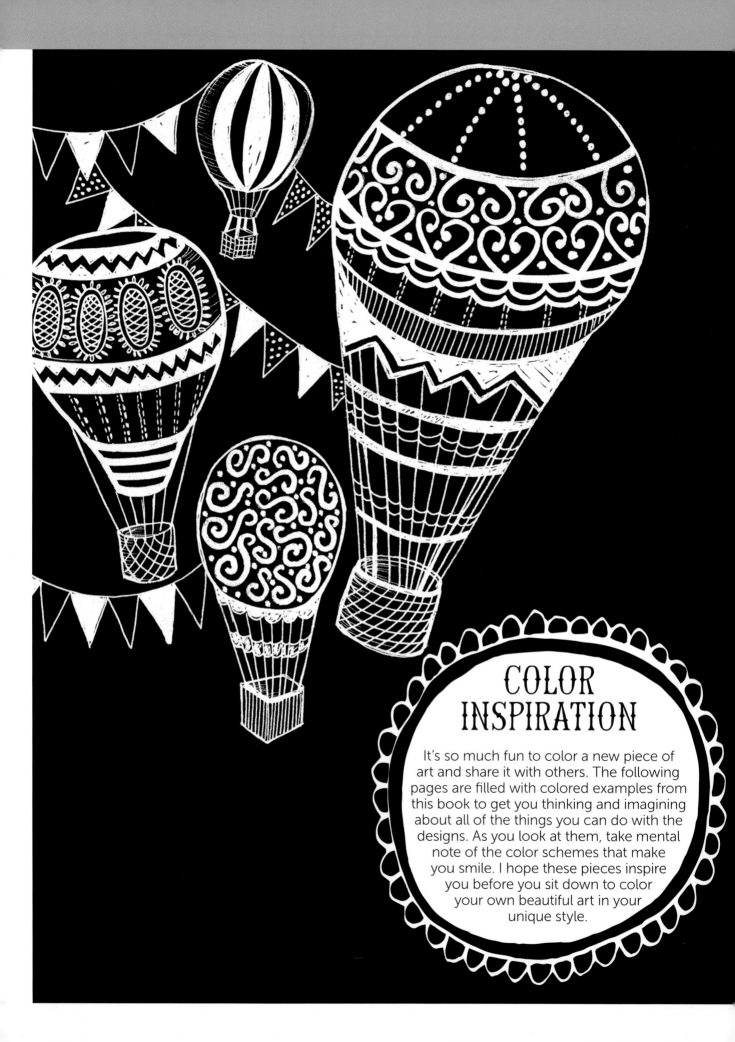

COLOR
INSPIRATION

It's so much fun to color a new piece of art and share it with others. The following pages are filled with colored examples from this book to get you thinking and imagining about all of the things you can do with the designs. As you look at them, take mental note of the color schemes that make you smile. I hope these pieces inspire you before you sit down to color your own beautiful art in your unique style.

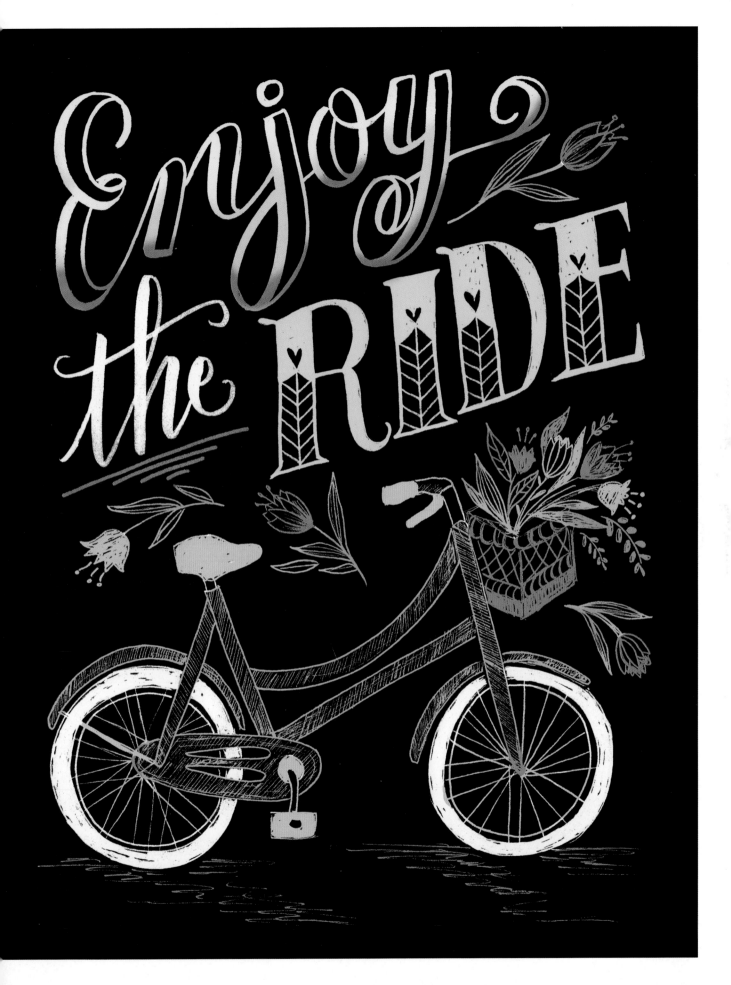

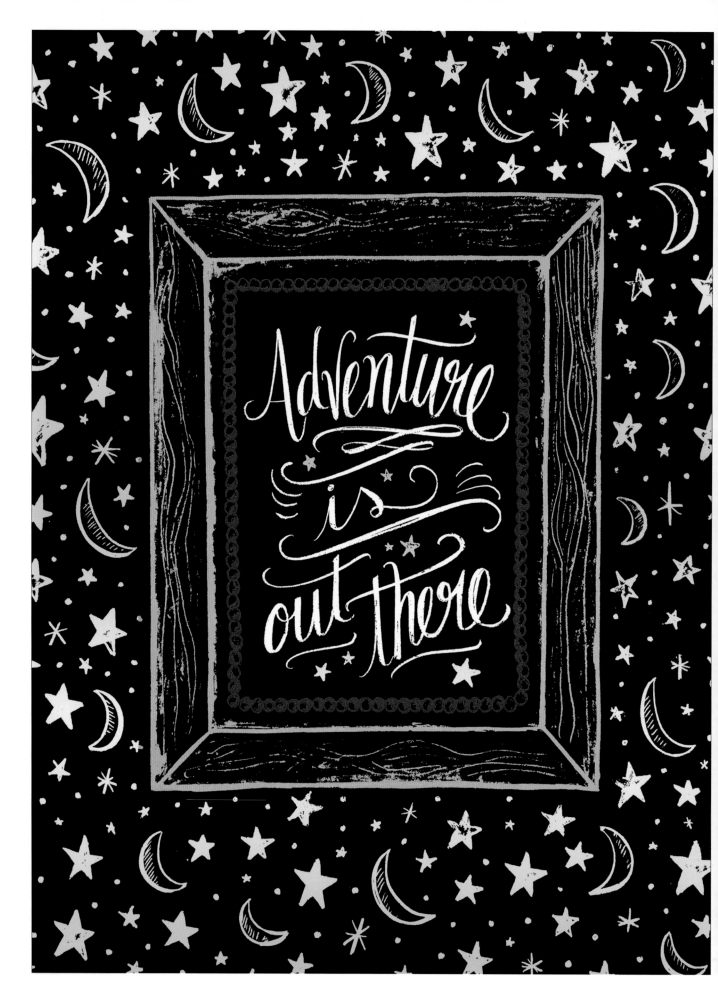

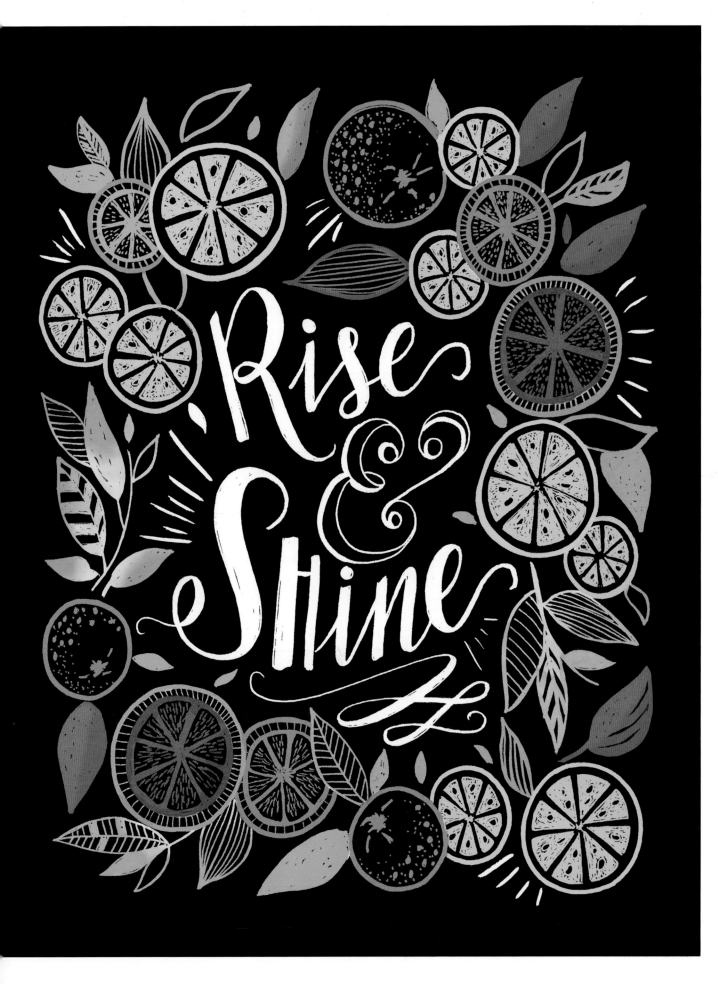

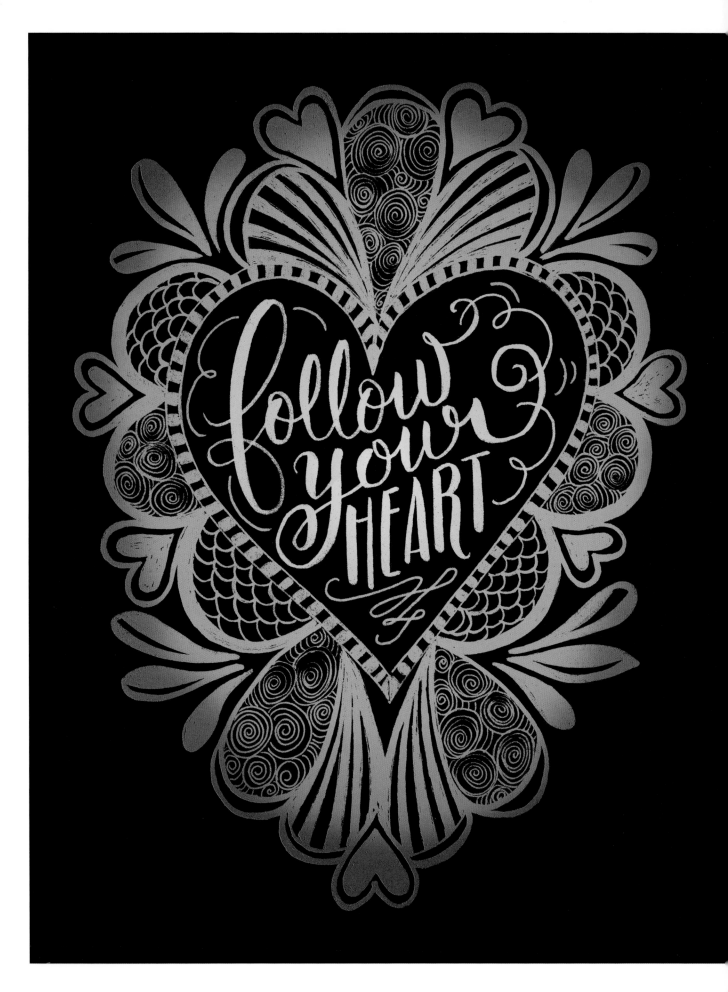

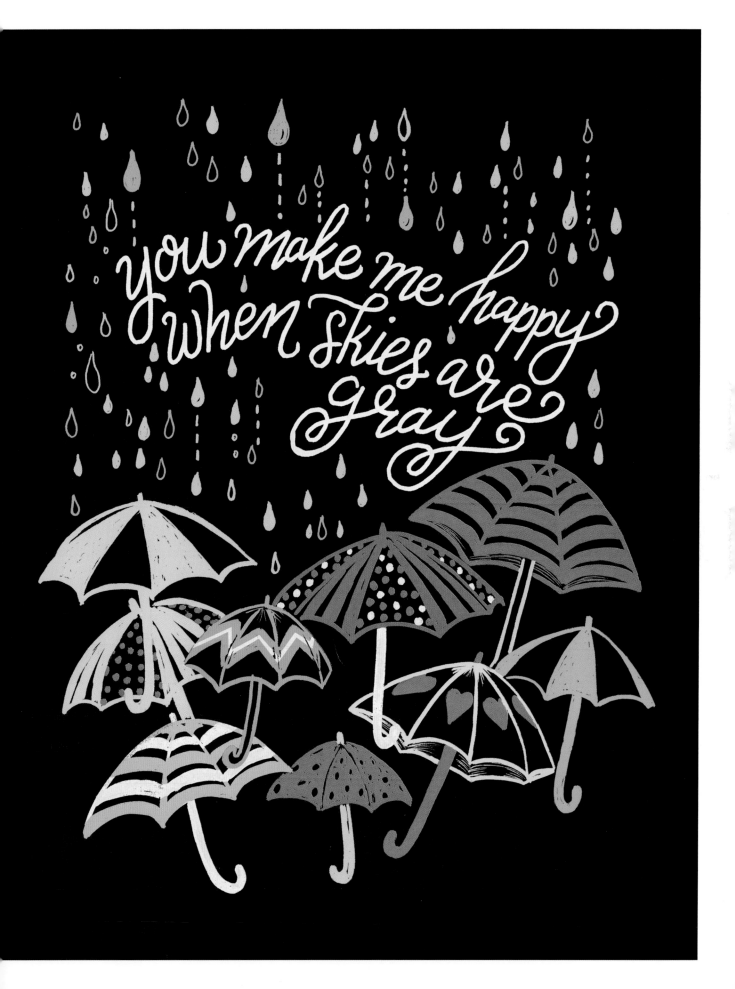

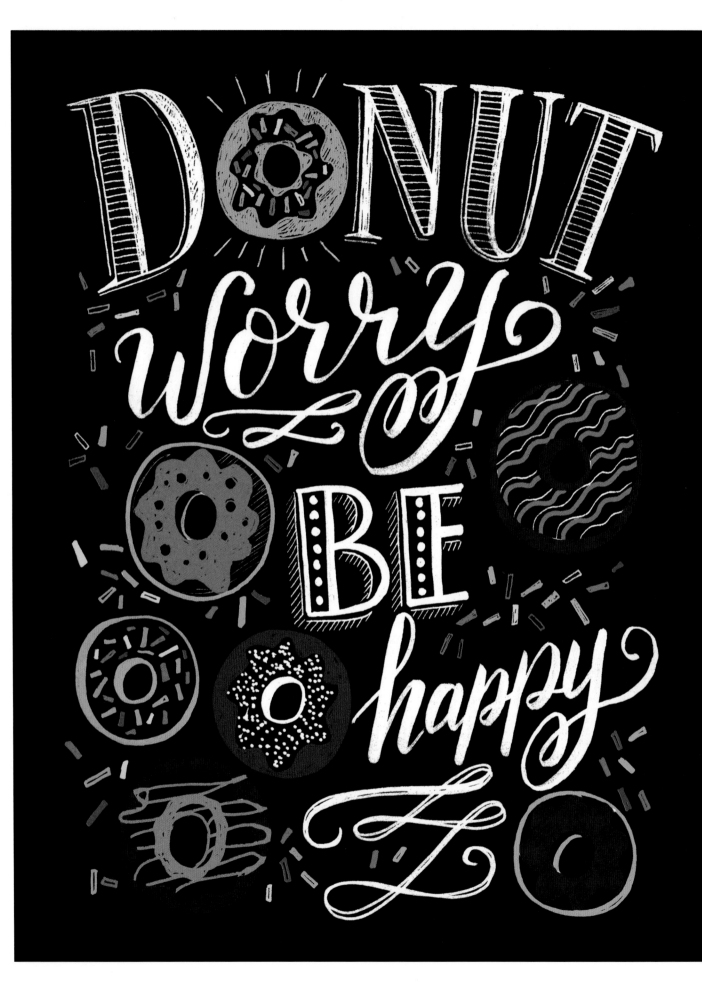

LIFE MOVES *Pretty* **FAST** IF YOU DON'T STOP & LOOK AROUND ONCE IN A WHILE YOU COULD *miss it* — FERRIS BUELLER

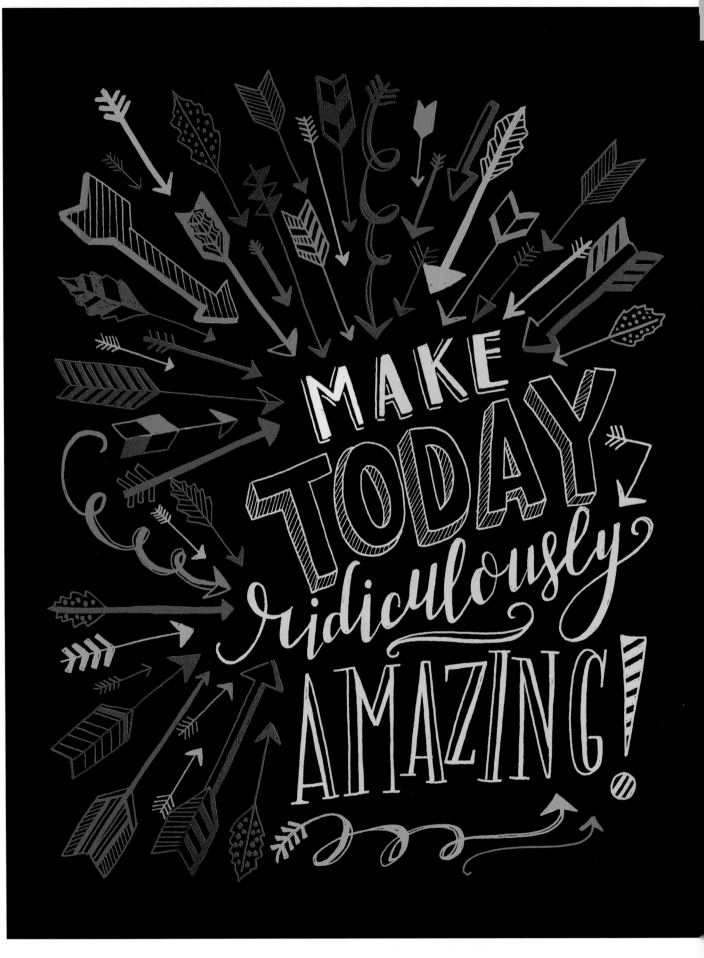

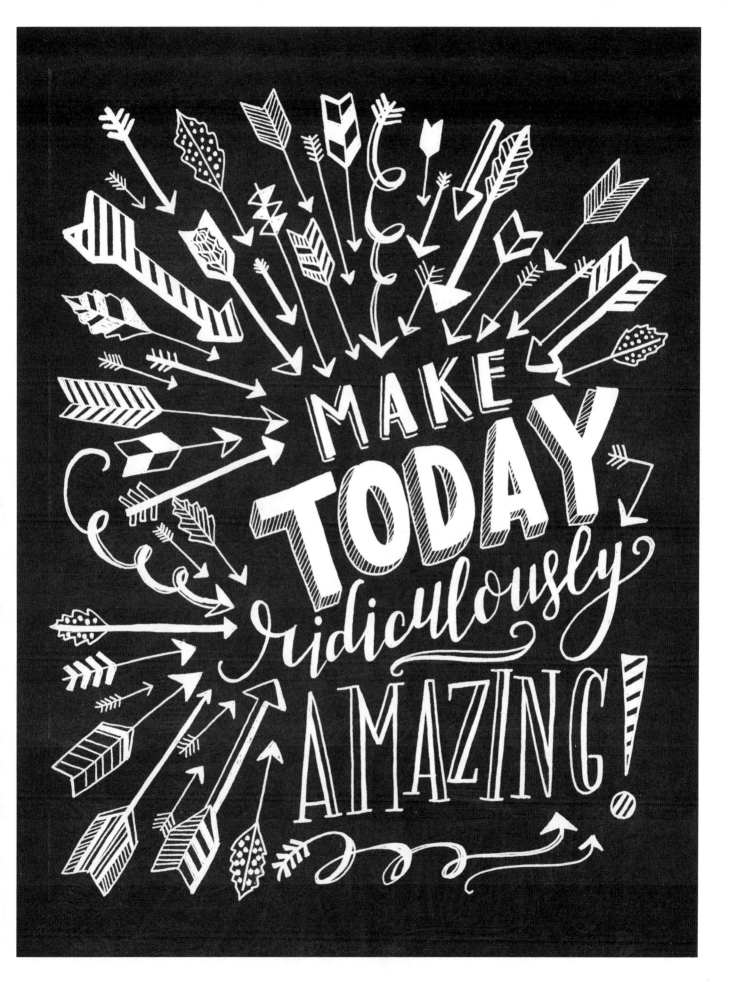

Don't wait for extraordinary opportunities,
seize common occasions and make them great.

—Orison Swett Marden

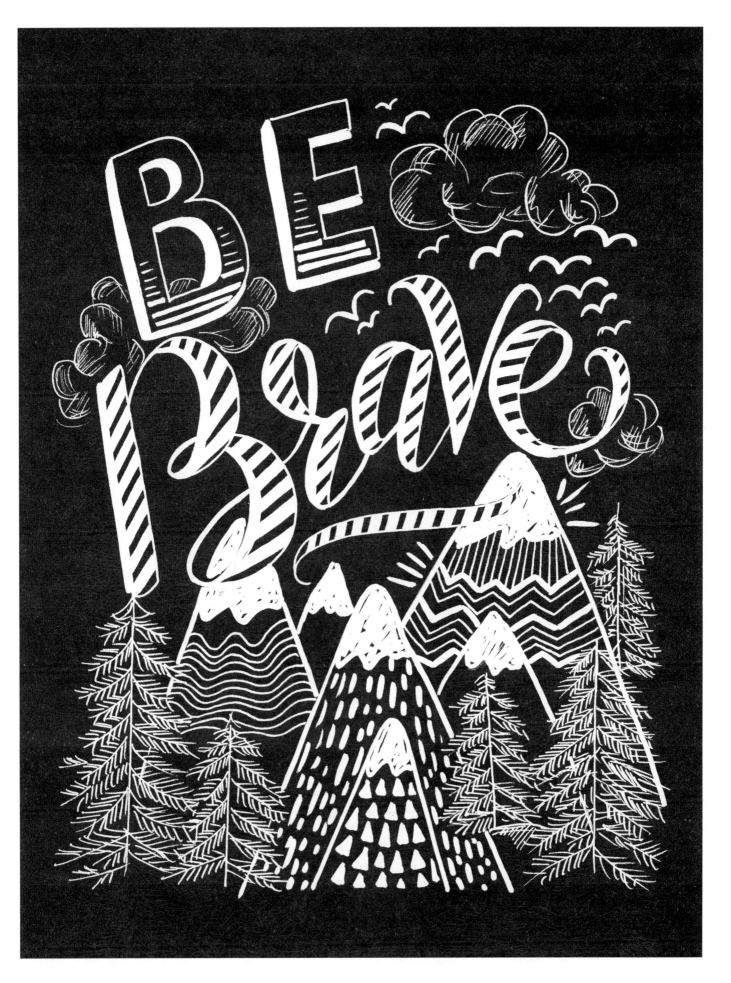

If it scares you, it might be a
good thing to try.

–Seth Godin

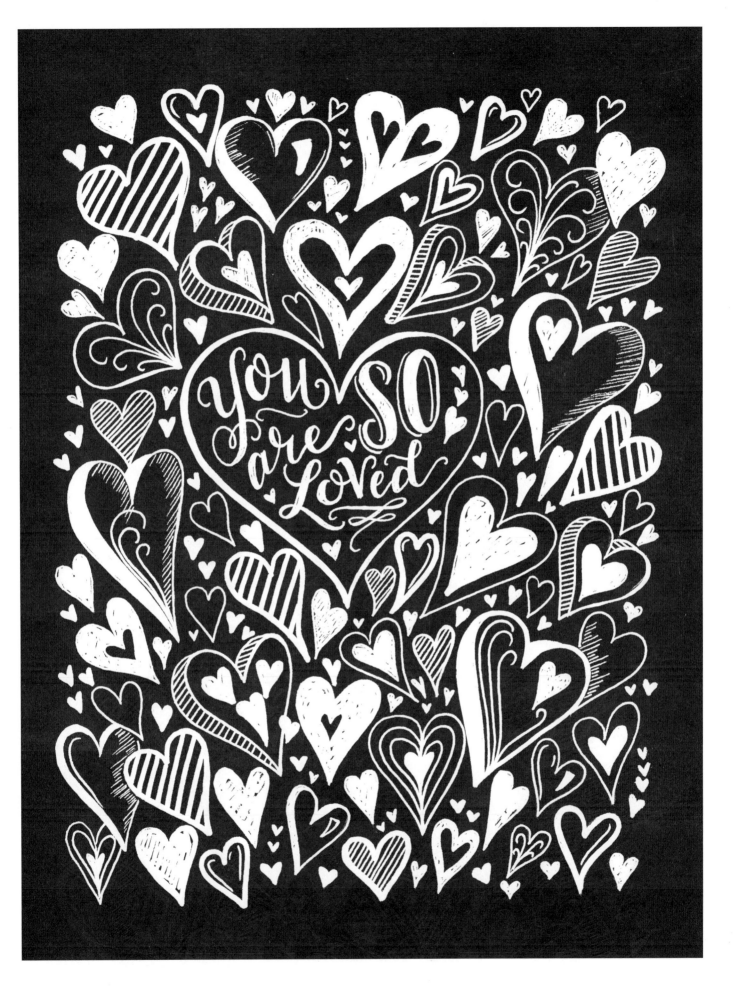

You are the finest, loveliest, tenderest,
and most beautiful person I have ever known—
and even that is an understatement.

-F. Scott Fitzgerald

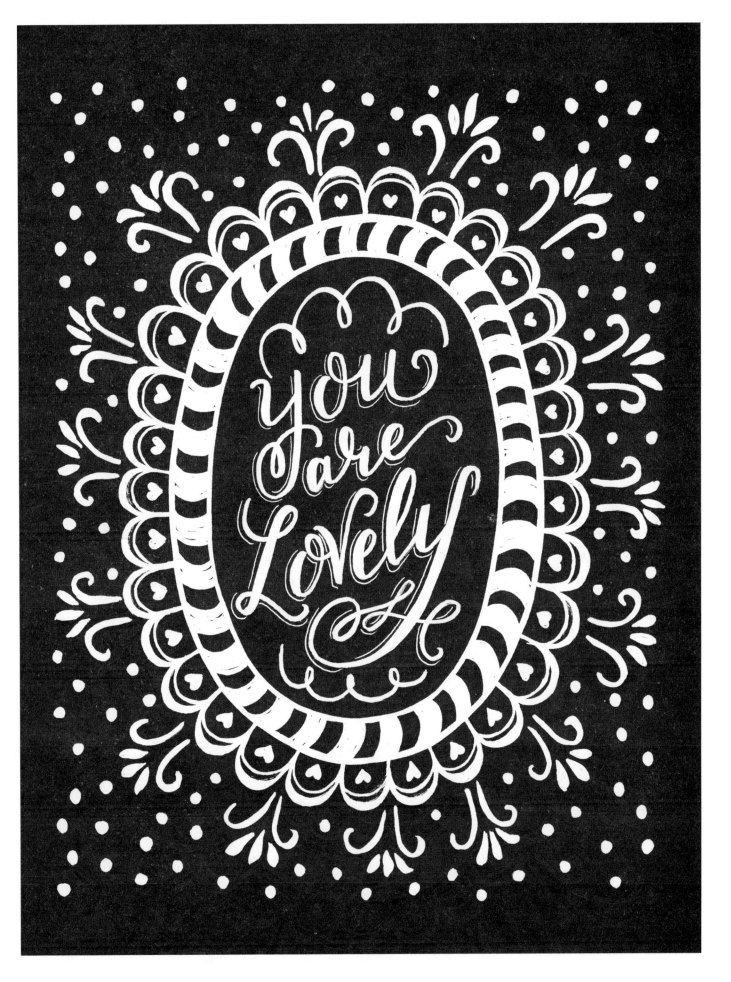

There is only one of you.
You are the only you that there is.
You are the most majestic and rare you
that there ever was and ever will be.

—*Jenna Marbles*

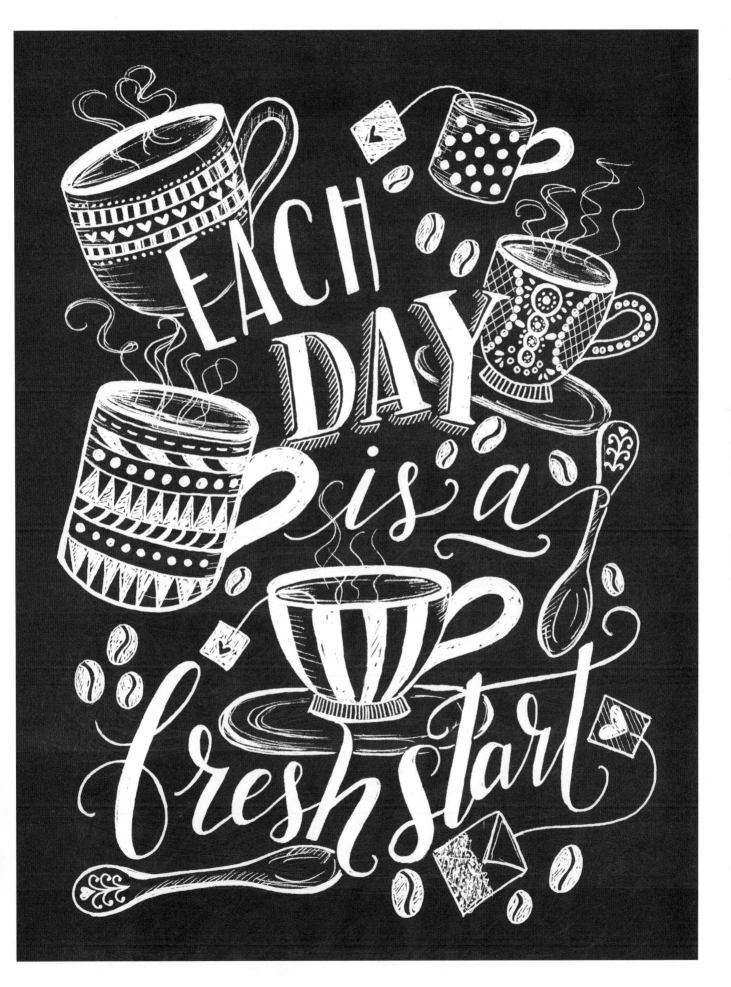

With the new day comes new strength and new thoughts.

–Eleanor Roosevelt

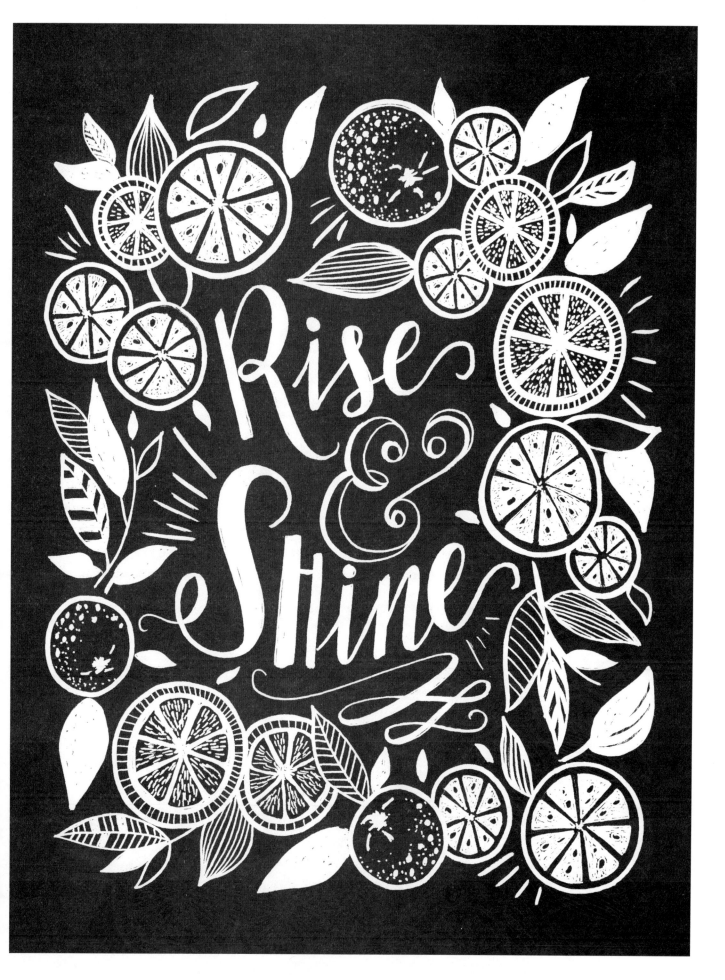

The day will be what you make it,
so rise, like the sun, and burn.

–*William C. Hannan*

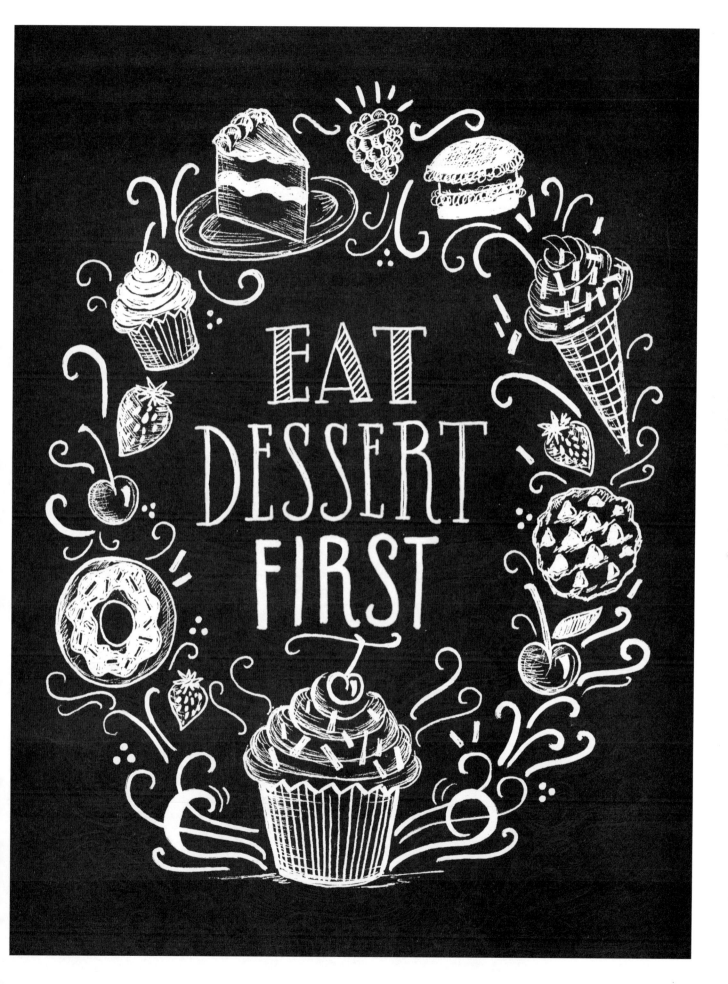

Life is for deep kisses, strange adventures,
midnight swims, and rambling conversations.

—Unknown

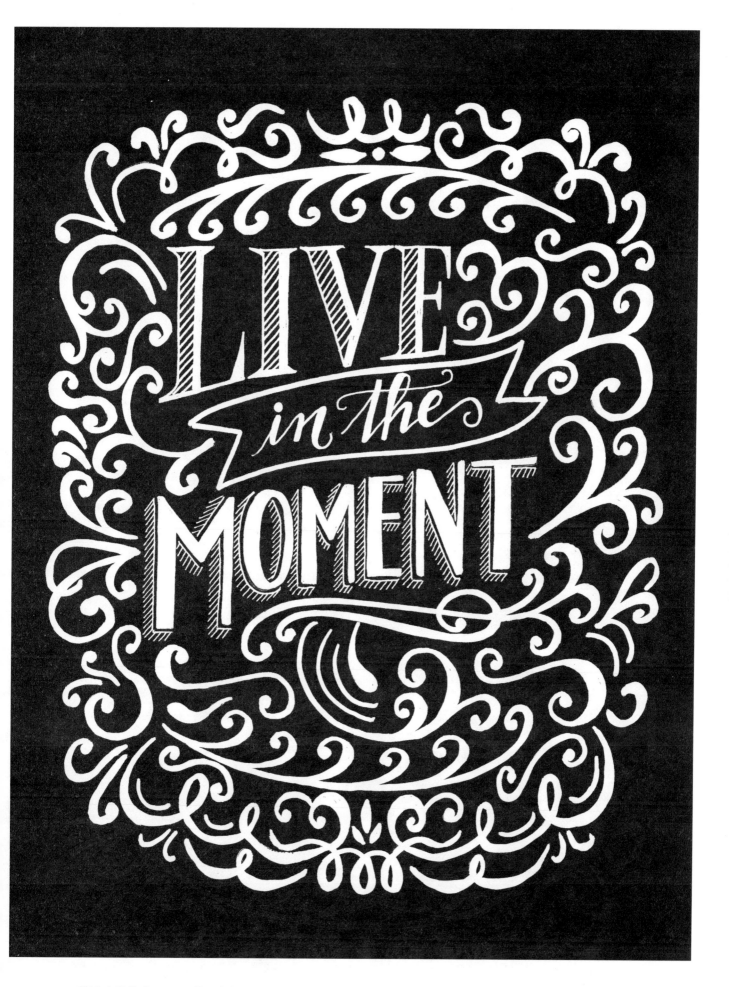

Fully embrace the now, no matter what the situation.

–Unknown

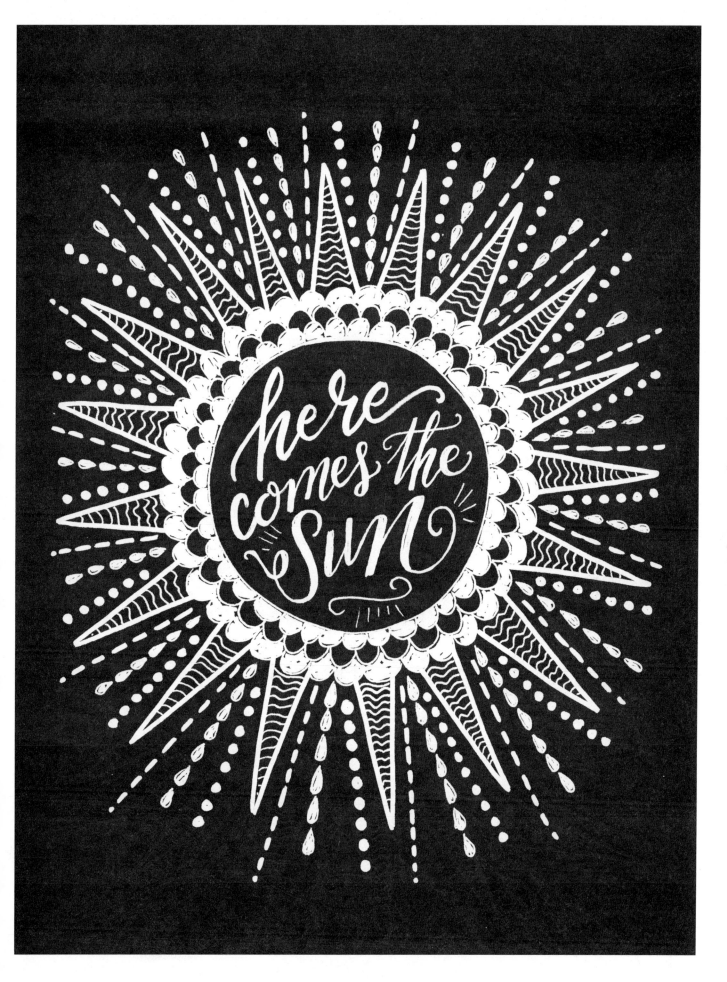

The greater your storm, the brighter your rainbow.

—Unknown

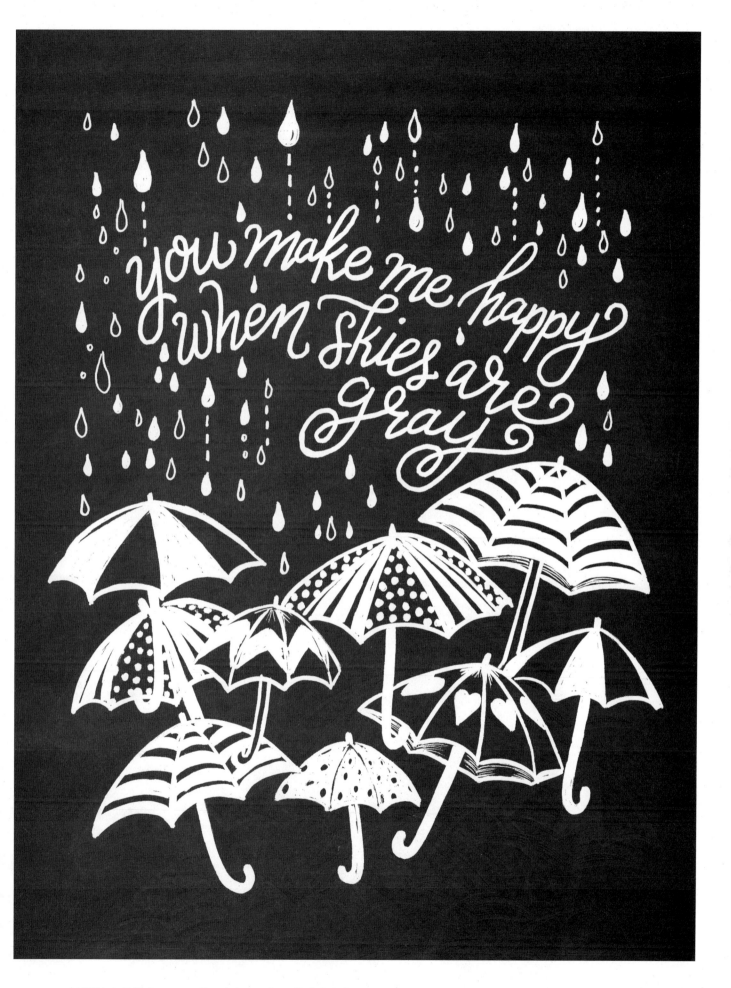

When someone else's happiness is
your happiness, that is love.

–Lana Del Rey

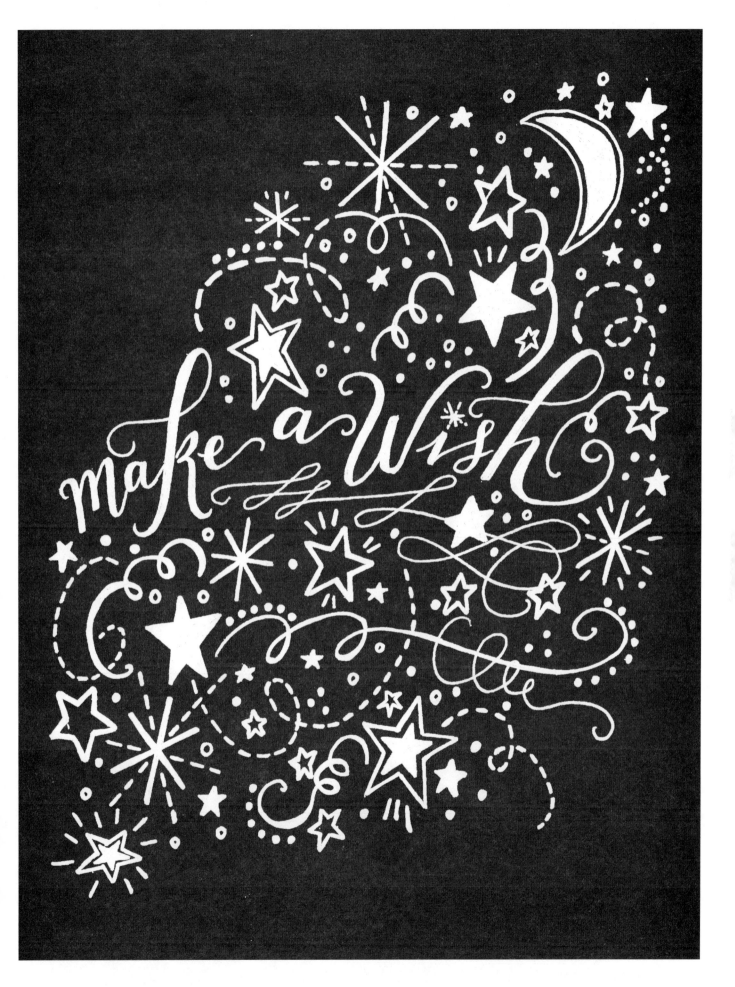

You are never given a wish without also being given the power to make it come true.

–Richard Bach

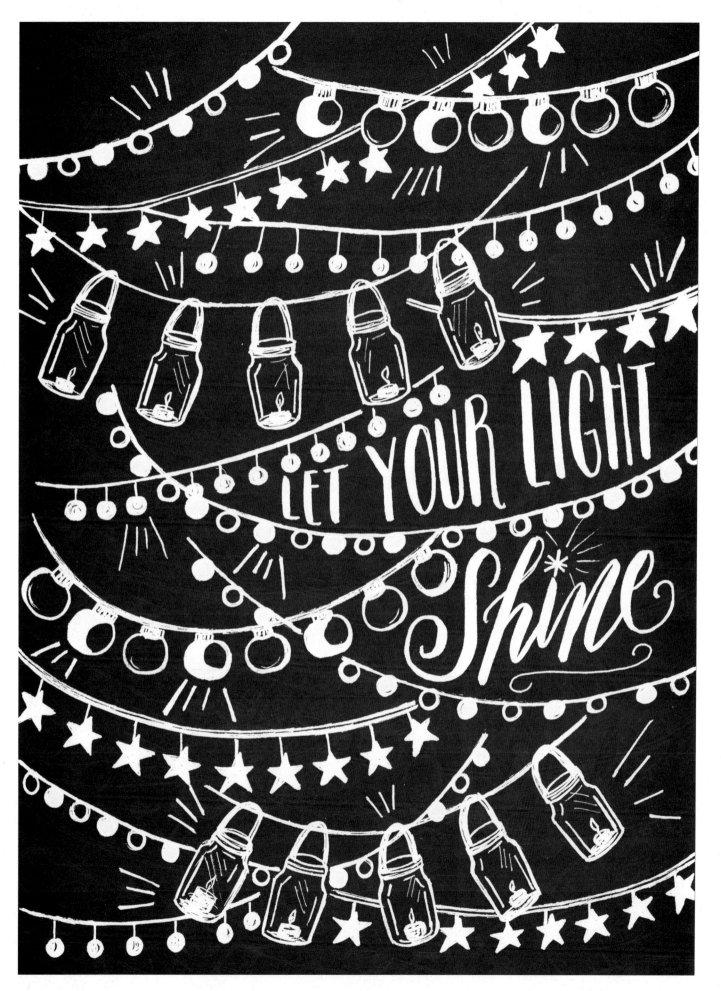

Beware; for I am fearless, and therefore powerful.

–Mary Shelley

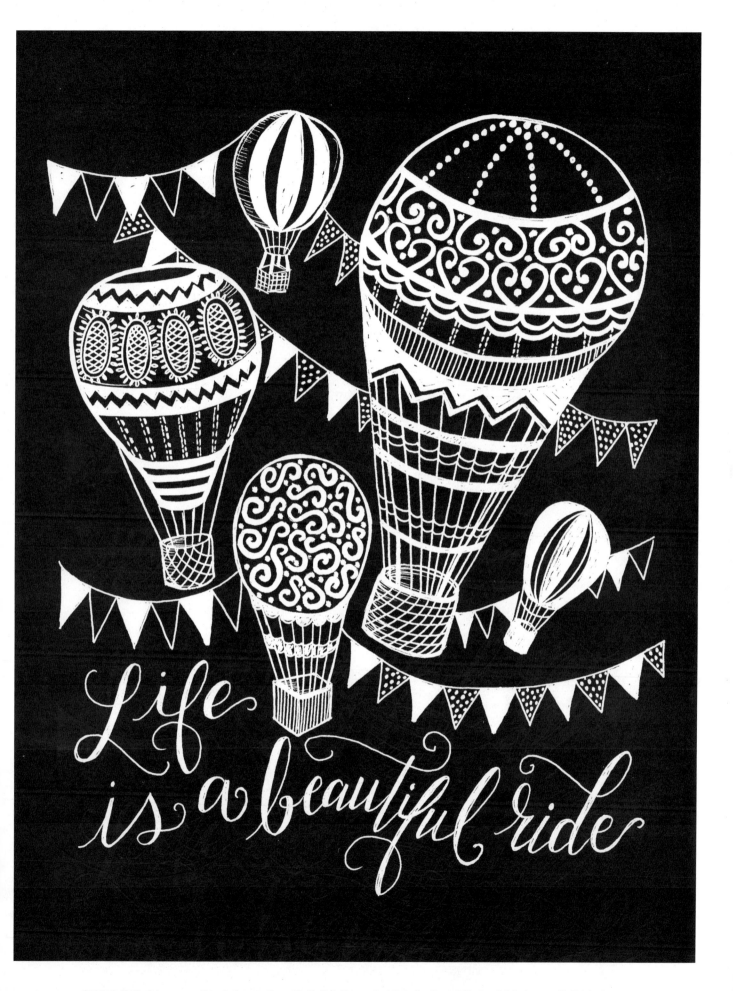

Be in love with your life.
Every minute of it.

–Jack Kerouac

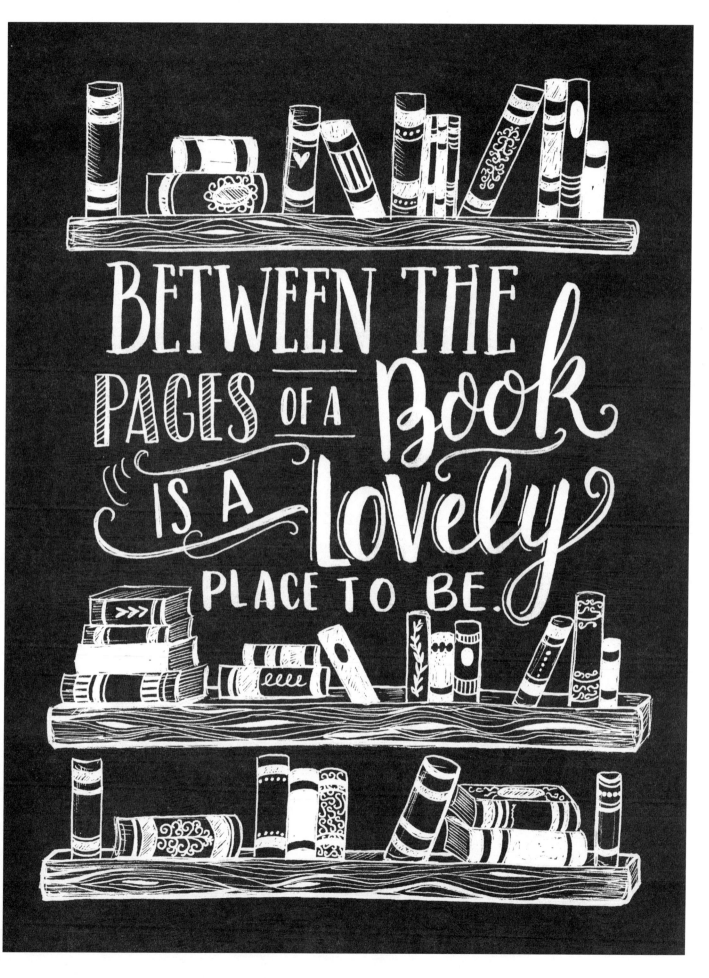

You know you've read a good book
when you turn the last page and feel
a little as if you have lost a friend.

–Paul Sweeney

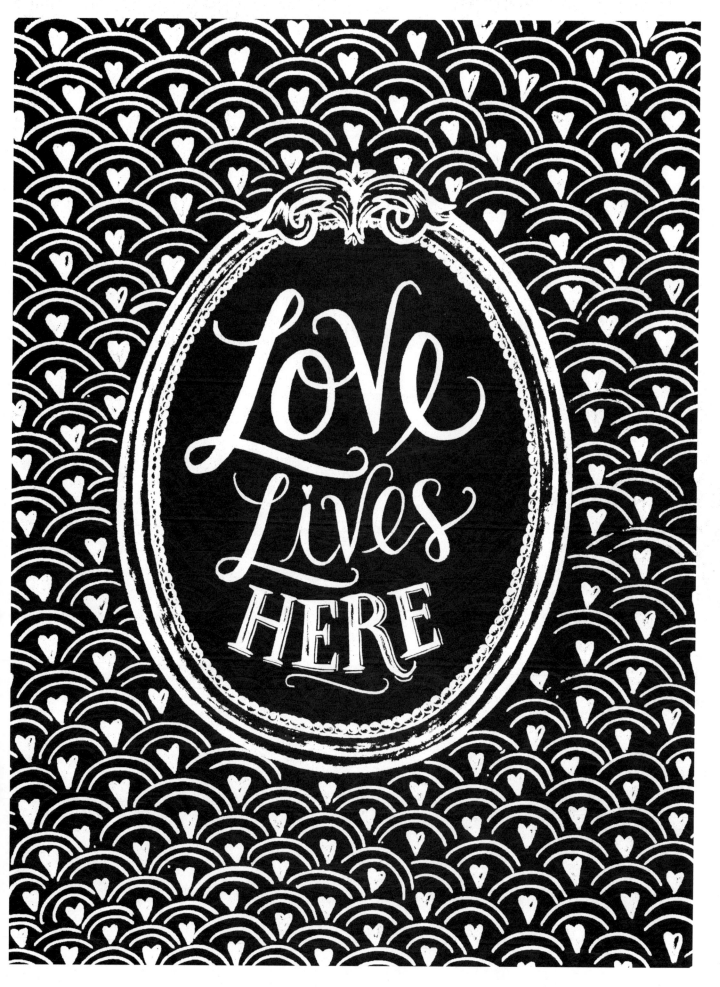

For there we loved, and where we love is home,
Home that our feet may leave, but not our hearts

—Oliver Wendell Holmes, Sr., *Homesick in Heaven*

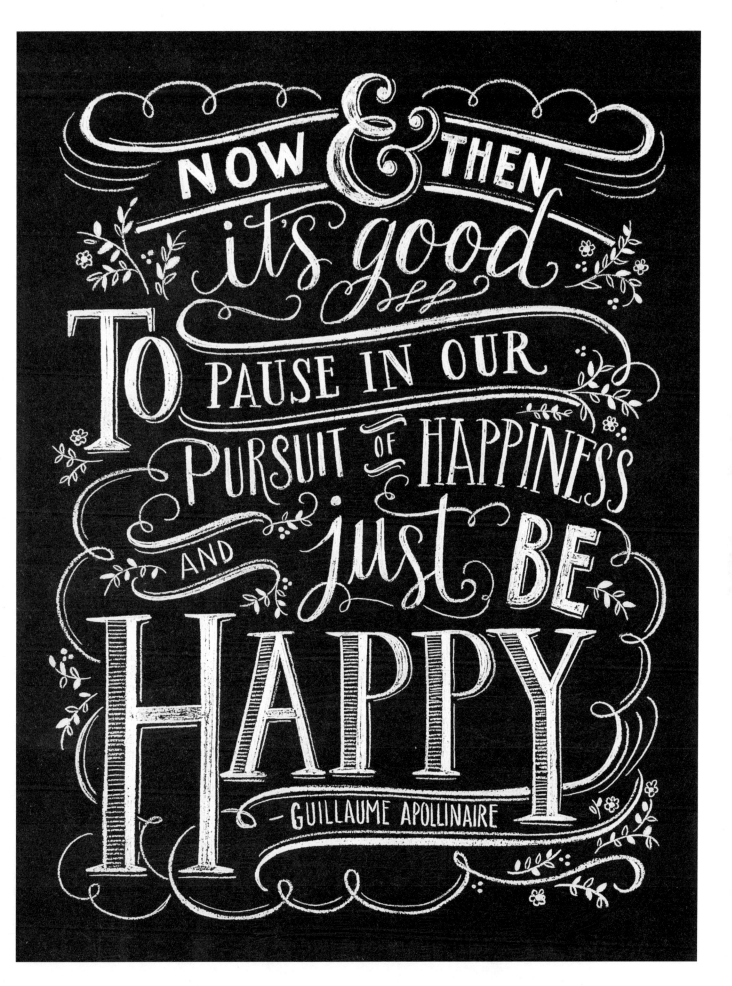

NOW & THEN it's good TO PAUSE IN OUR PURSUIT OF HAPPINESS AND JUST BE HAPPY

— GUILLAUME APOLLINAIRE

The moments of happiness
we enjoy take us by surprise.
It is not that we seize them,
but that they seize us.

Ashley Montagu

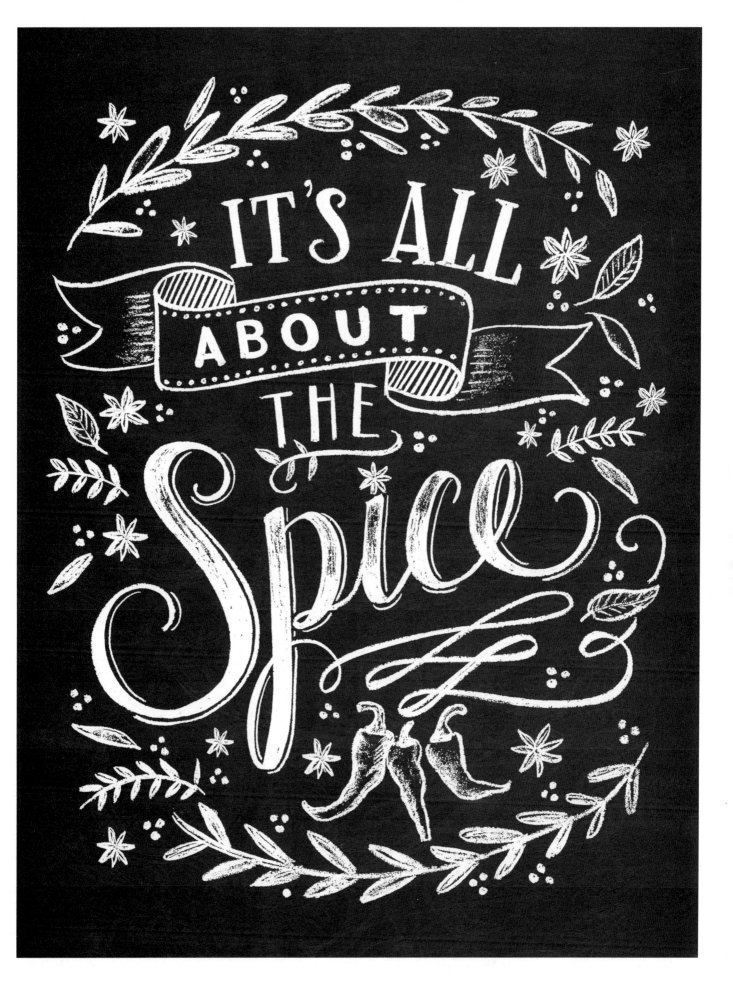

Variety's the very spice of life,
That gives it all its flavor.

–*William Cowper*

We must take adventures in order to
know where we truly belong.

–Unknown

A single dream is more powerful than a thousand realities.

-J. R. R. Tolkien

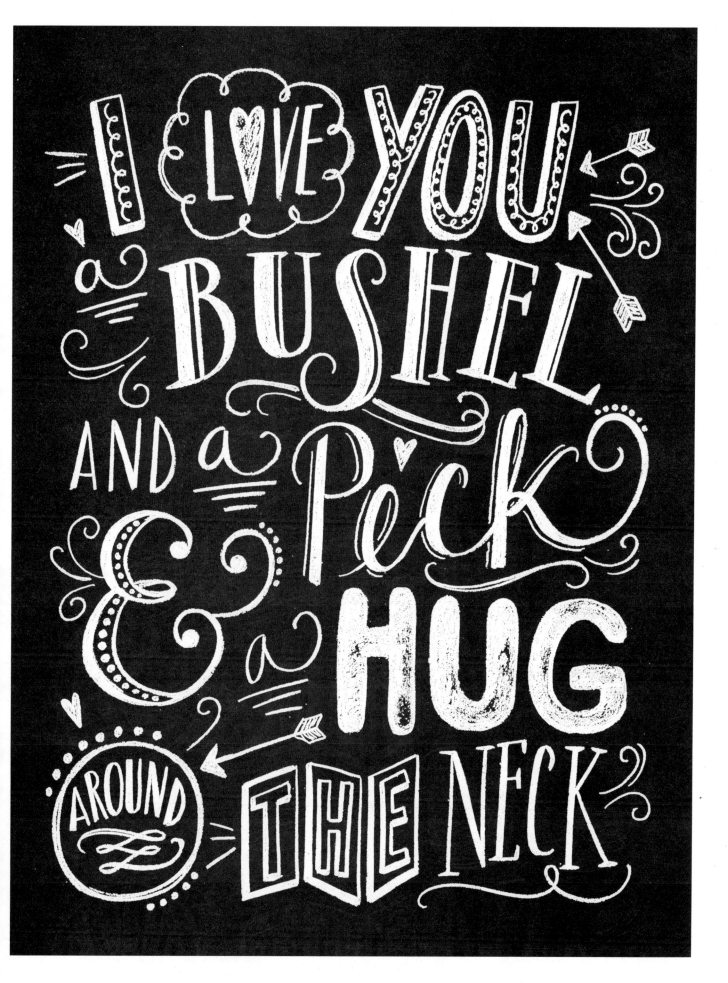

Have a heart that never hardens,
and a temper that never tires,
and a touch that never hurts.

—Charles Dickens

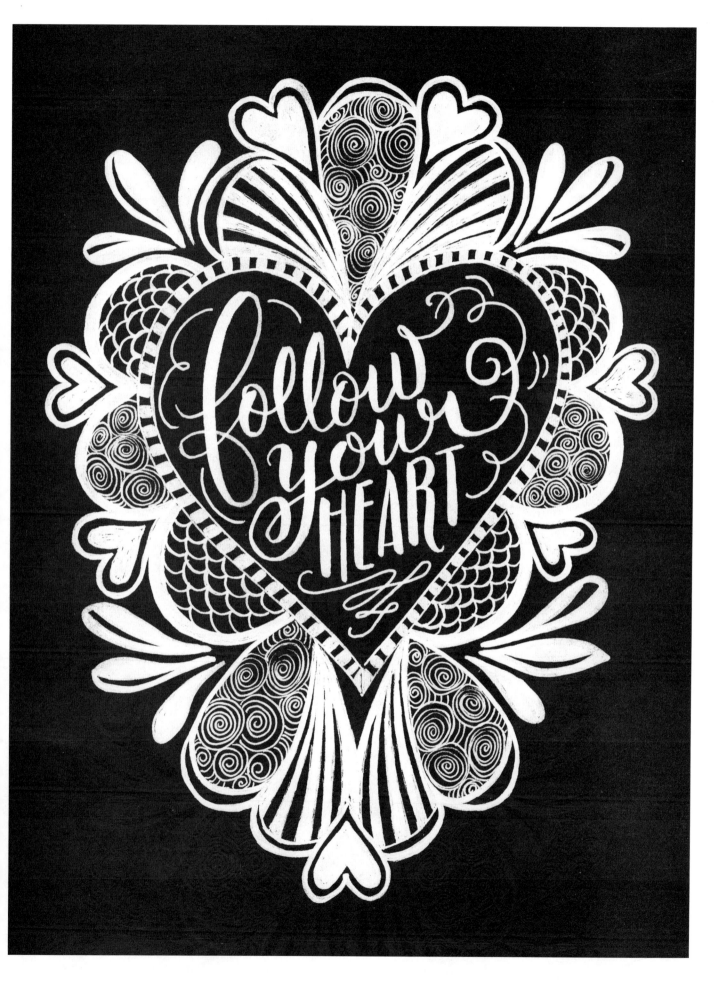

Lose yourself in the things you love, for that
is where you will find yourself too.

—Unknown

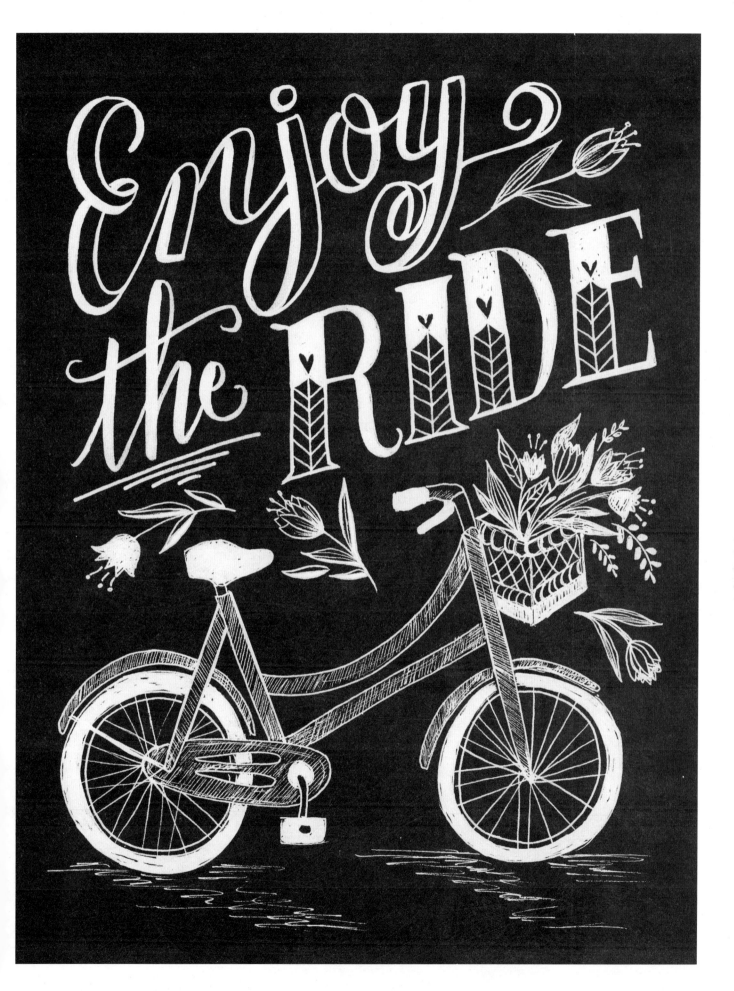

Don't wait for everything to be perfect
before you decide to enjoy your life.

–Joyce Meyer

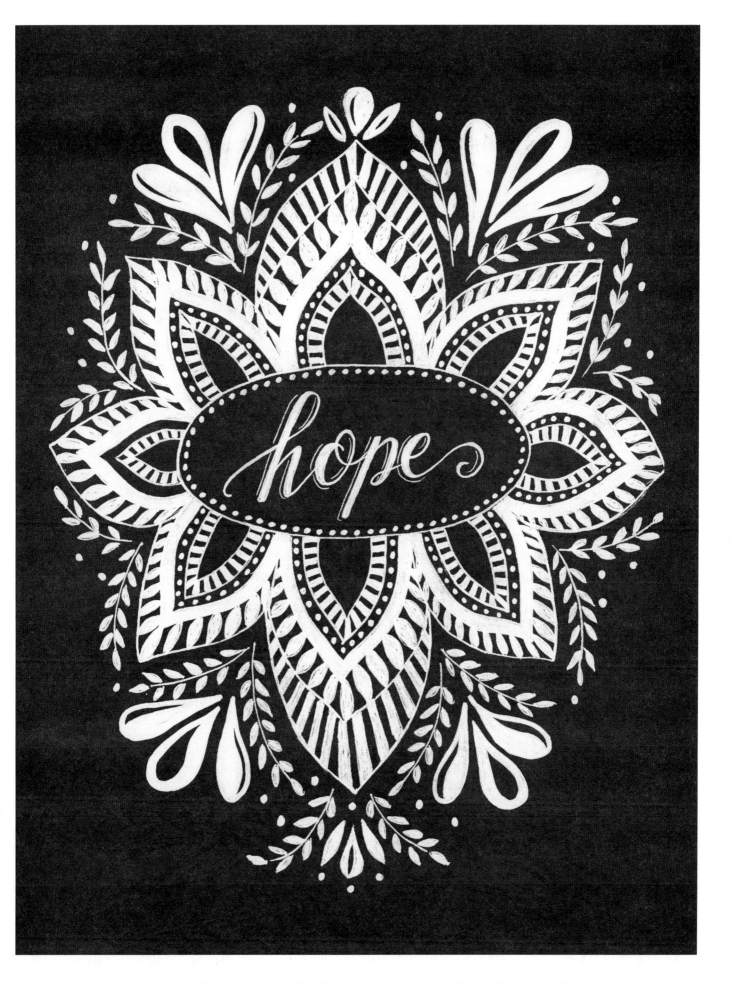

Everything that is done in the world is done by hope.

—Dr. Martin Luther King, Jr.

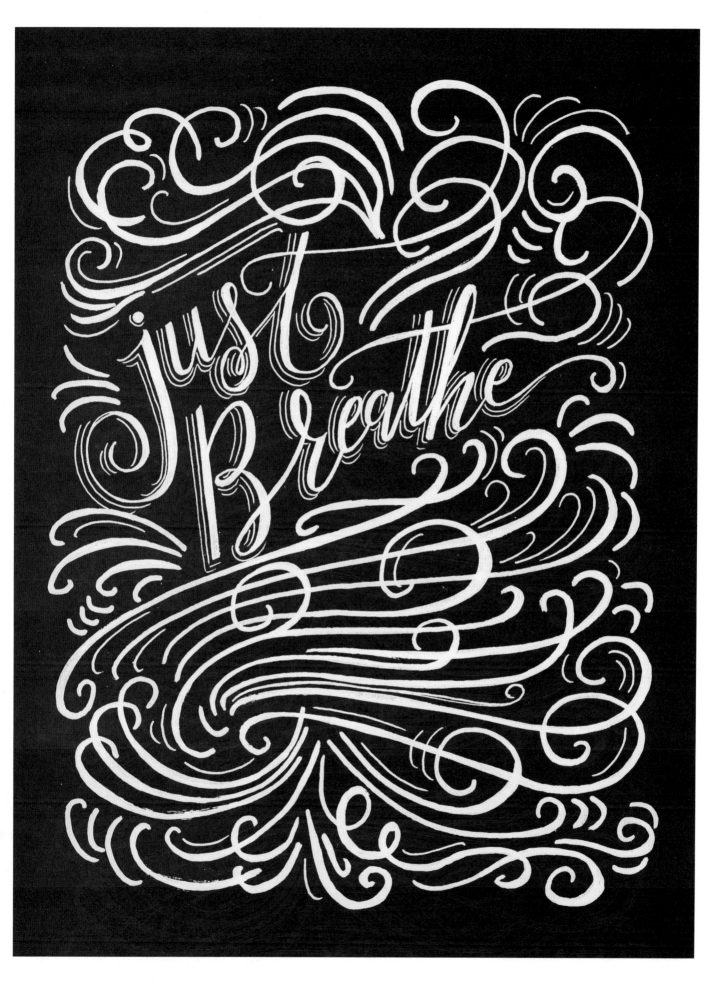

Not till we are lost...
do we begin to find ourselves.

—Henry David Thoreau

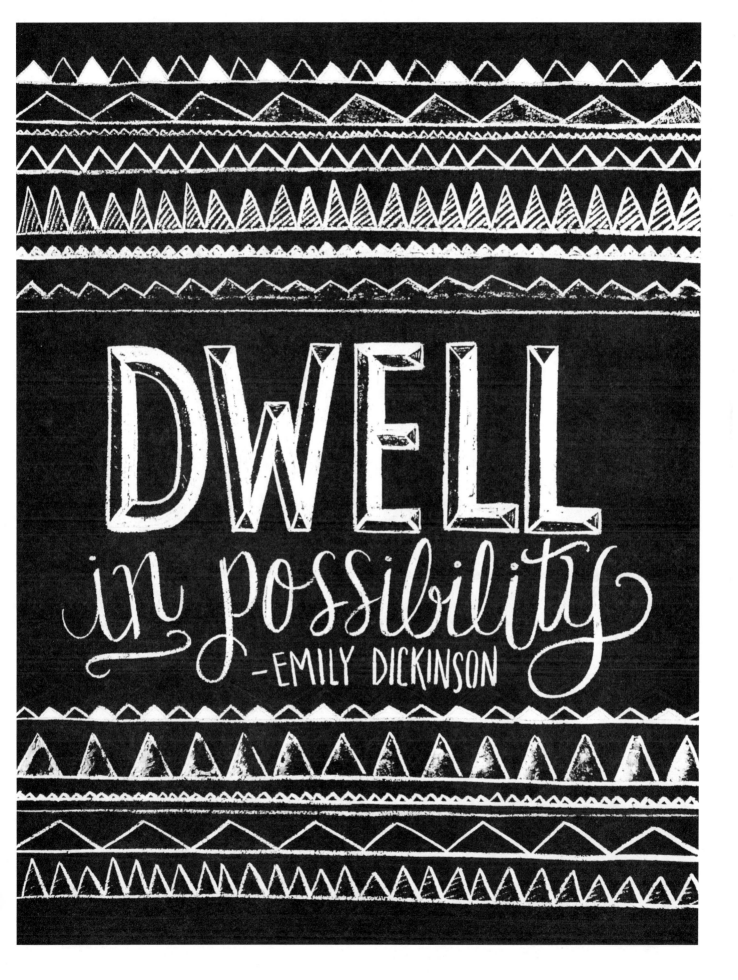

DWELL in possibility
—EMILY DICKINSON

Your life is an occasion. Rise to it.

–Suzanne Weyn

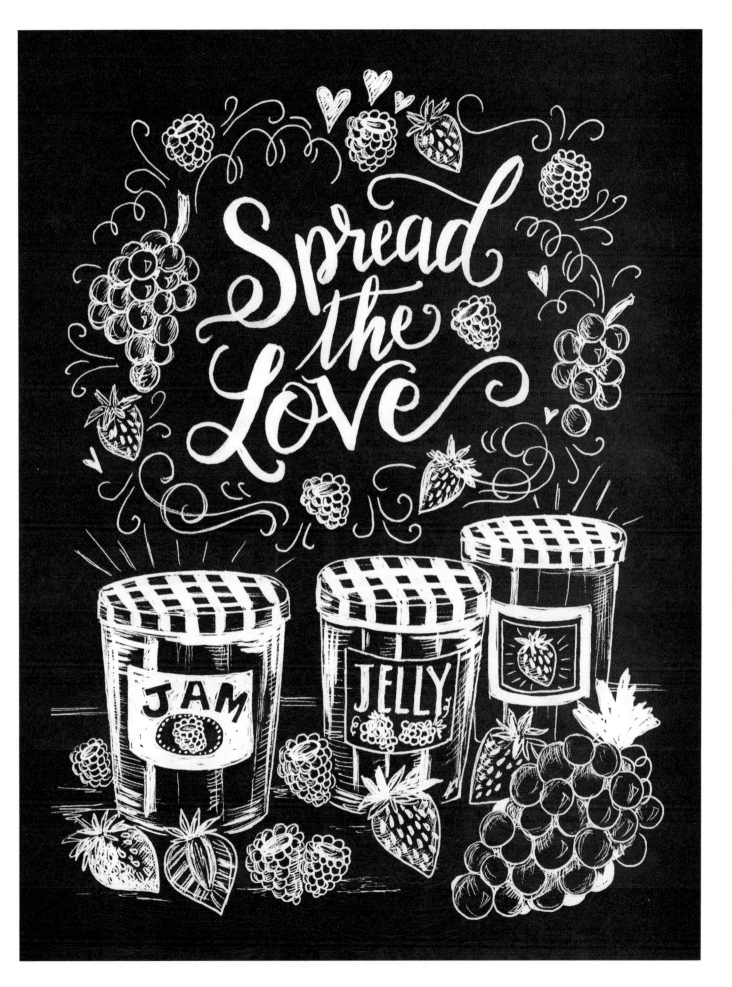

Seek more opportunities to put more love in the world.

—*Marianne Williamson*

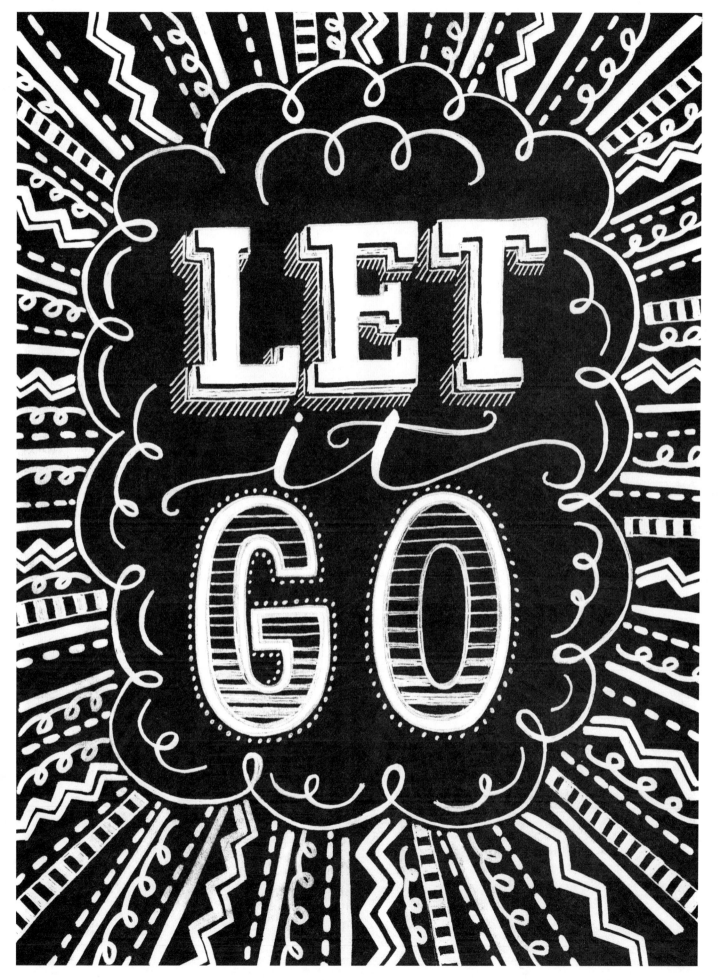

Sometimes what you're most afraid of doing
is the very thing that will set you free.

–Unknown

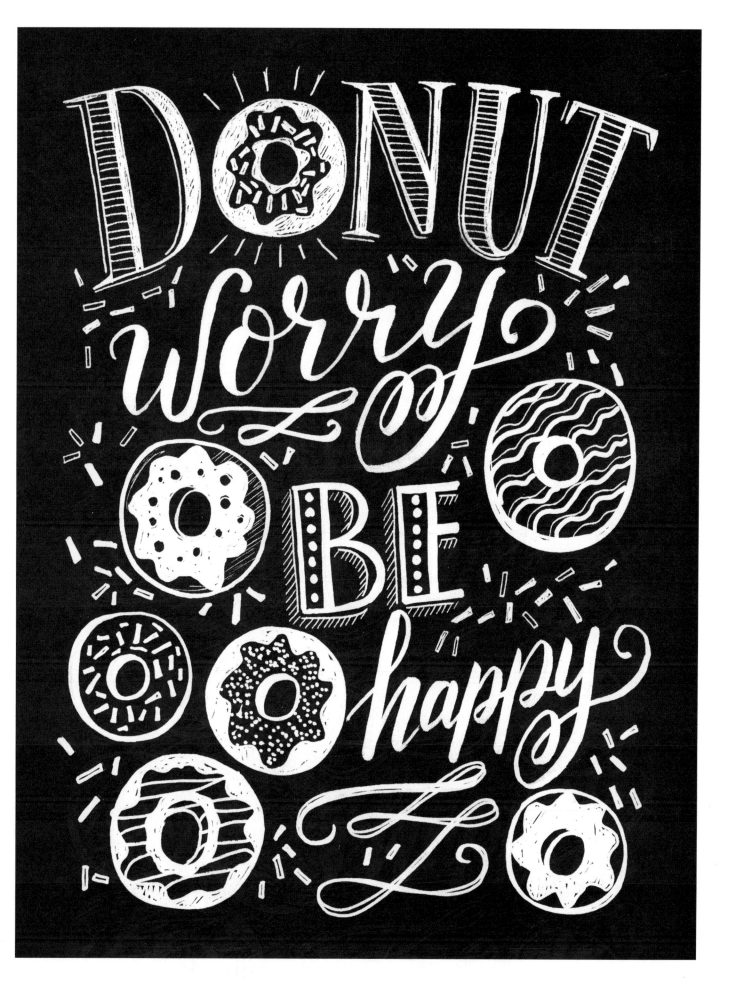

It is not how much we have
but how much we enjoy
that makes happiness.

–Charles Spurgeon

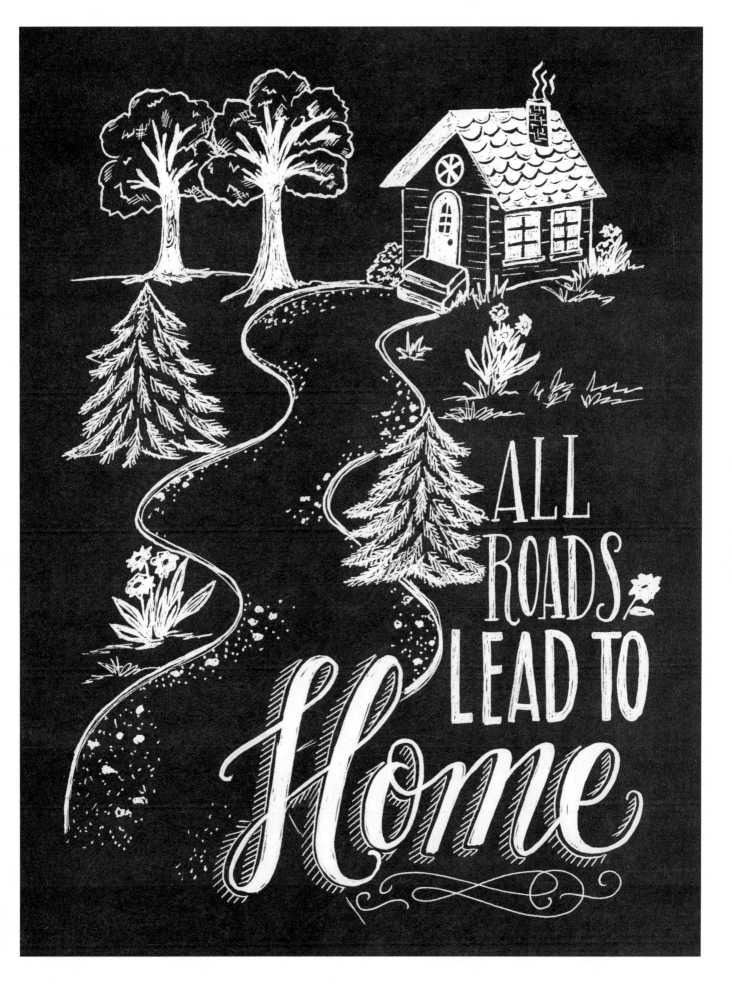

The magic thing about home is that it feels good
to leave, and it feels even better to come back.

—Wendy Wunder

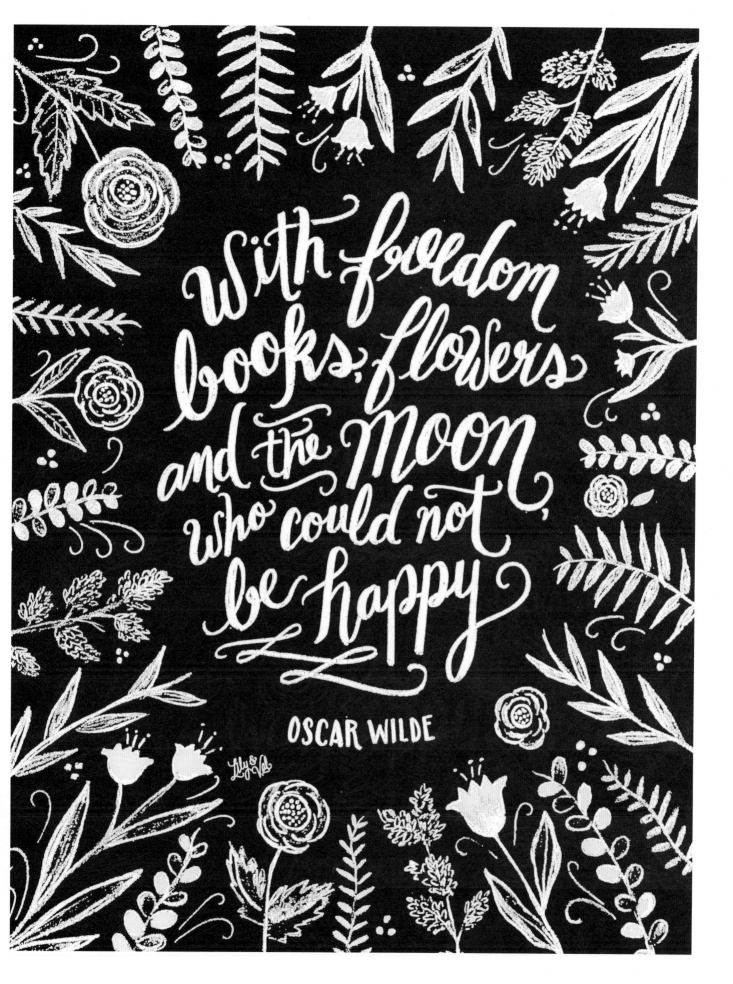

Life is a great bundle of little things.

–Unknown